Drawing Boats & Ships

Yngve Edward Soderberg

DOVER PUBLICATIONS, INC.
Mineola, New York

This book is dedicated to my wife Nancy

Bibliographical Note

This Dover edition, first published in 2008, is an unabridged republication of the work originally published by Pitman Publishing Corporation, New York, in 1959.

Library of Congress Cataloging-in-Publication Data

Soderberg, Yngve Edward.
 Drawing boats and ships / Yngve Edward Soderberg.
 p. cm.
 Originally published: New York : Pitman Pub. Corp., 1959.
 ISBN-13: 978-0-486-46033-8
 ISBN-10: 0-486-46033-9
 1. Ships in art. 2. Boats and boating in art. 3. Drawing—Technique. I. Title.

NC825.S5S6 2008
743'.8962381—dc22

2007053038

Manufactured in the United States of America
Dover Publications, Inc., 31 East 2nd Street, Mineola, N.Y. 11501

INTRODUCTION

In this era of abstract and nonobjective art it perhaps seems strange to put out a book called *Drawing Boats and Ships*. Yet any teacher or practicing artist knows that it is necessary to learn to draw before attempting to paint in any medium and in any form of realistic or abstract art. Every work of art is an abstraction of what the artist has seen and felt.

Why learn to draw boats? If you love the great outdoors, the beauties of nature, and especially the movement of boats on the water, then this book may serve its purpose.

The best way to develop your powers of observation is to carry a sketch book and start making sketches of anything that interests you. Just jotting down a few lines of some boats at a dock or under sail will be important to you at some future time. Learn to draw only what is important, giving it your interpretation. Later, you may want to get away from realism, and your knowledge of drawing will be a point of departure into the world of creative forms in art.

Most of the drawings in this book were made from sketches prepared during the past several years. The yachts, square-rigged ships and fishing boats were sketched in places ranging from Cape Breton, Nova Scotia, to the West Indies.

It may be coincidence that the first etching I made and one of my most recent plates are very similar in subject. They represent a span of thirty-eight years of drawing boats and ships

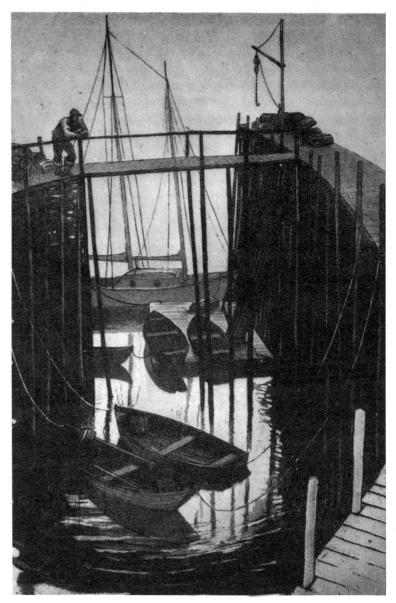

Neap Tide

First Etching

BASIC FORMS IN HULLS

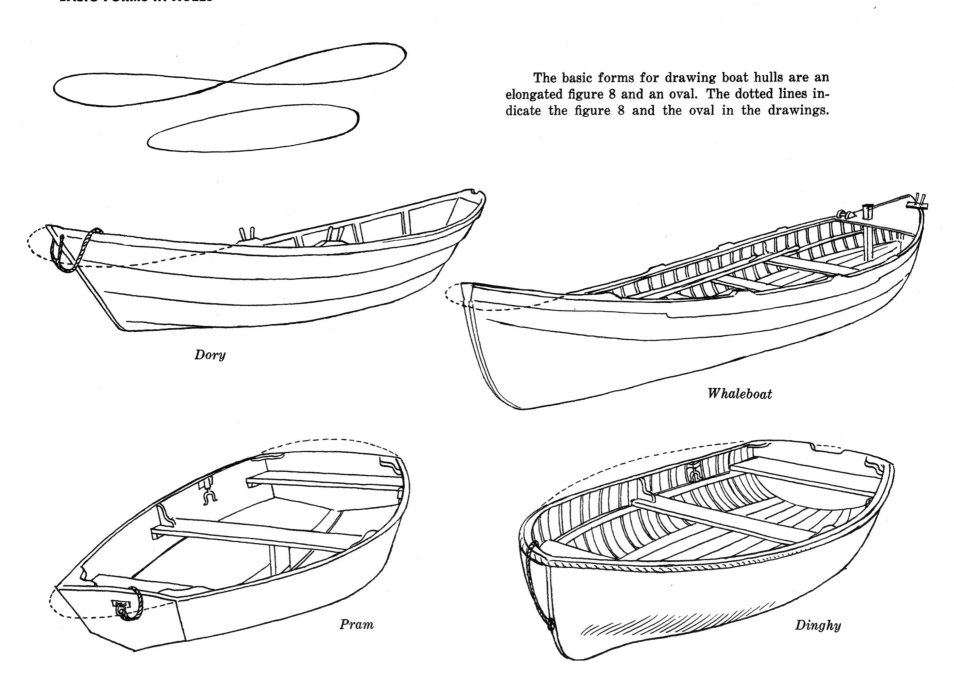

The basic forms for drawing boat hulls are an elongated figure 8 and an oval. The dotted lines indicate the figure 8 and the oval in the drawings.

Dory

Whaleboat

Pram

Dinghy

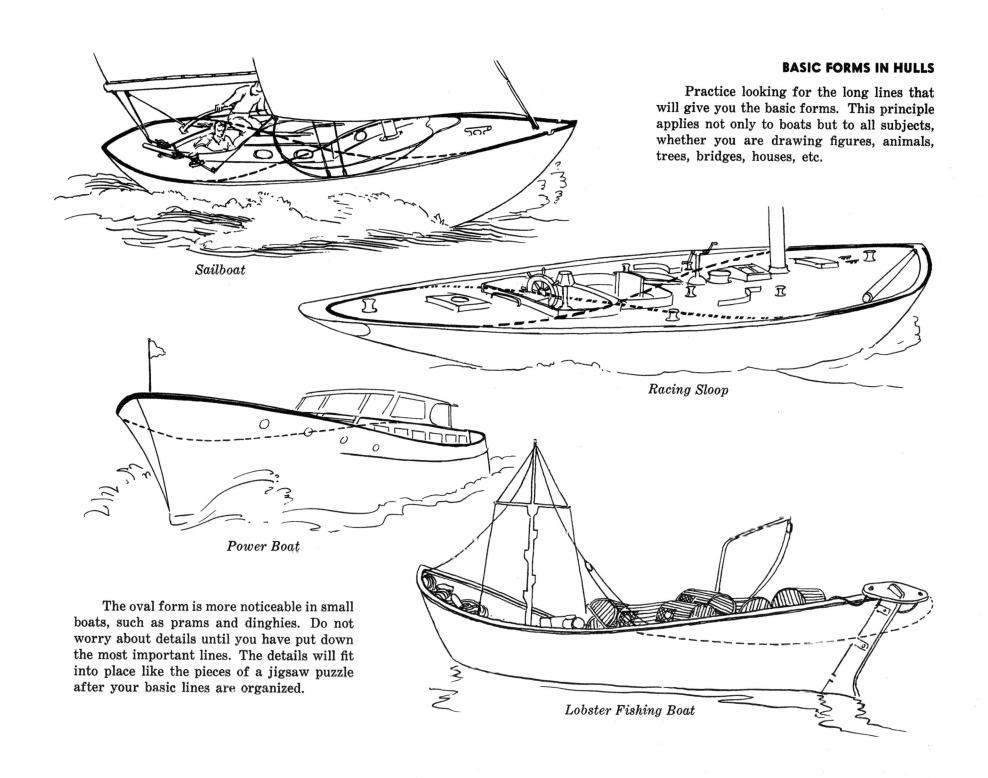

BASIC FORMS IN HULLS

Practice looking for the long lines that will give you the basic forms. This principle applies not only to boats but to all subjects, whether you are drawing figures, animals, trees, bridges, houses, etc.

Sailboat

Racing Sloop

Power Boat

The oval form is more noticeable in small boats, such as prams and dinghies. Do not worry about details until you have put down the most important lines. The details will fit into place like the pieces of a jigsaw puzzle after your basic lines are organized.

Lobster Fishing Boat

PERSPECTIVE

Perspective is the technique of drawing objects as they appear to the eye. Perspective is determined by your eye level, which fixes the horizon at a certain height in relation to the top and bottom of your drawing.

If you are sitting near the water, the horizon will be in the lower part of your picture, showing more sky than water.

If you are on a high point, the horizon will be in the upper part of your drawing, showing more water than sky.

Reflections appear directly under the point of contact with the surface of the water. If the object is at an angle to the water, the reflection will be at the opposite angle. Take a mirror and hold a pencil at various angles to it. Tilt the pencil sideways, forward and backward. Notice how the angle of reflection reverses its direction. When the pencil leans toward you, the reflection is longer. When it leans away, the reflection is shorter.

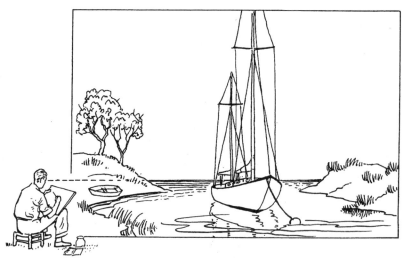

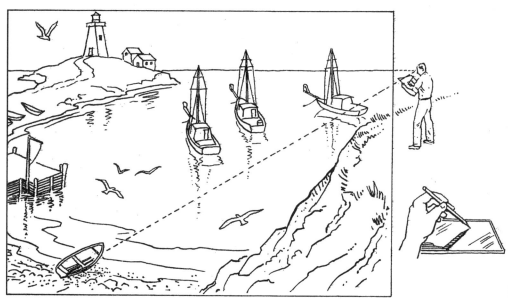

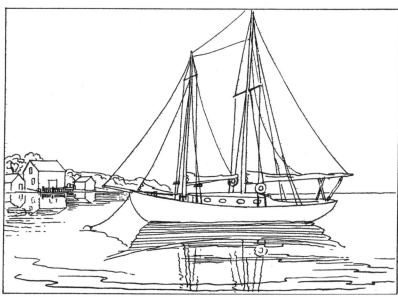

Before going into the drawing of various types of boats, it is important to know how to arrange the subject within the four sides of your paper.

A marine subject is usually more suited to a horizontal than a vertical picture, due to the long line of the horizon. A peaceful and quiet marine subject is best expressed by long horizontal lines.

Action is shown by diagonal lines. This fact will be helpful to you in drawing sailboats that suggest speed. More wind on the sail will heel the boat at a greater angle to the perpendicular.

To give greater emphasis to the violent action of the boat use an opposing angle, such as a buoy or a cloud.

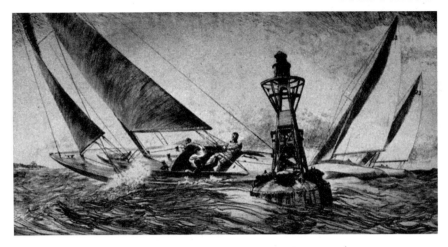

Splitting Tacks (Etching)

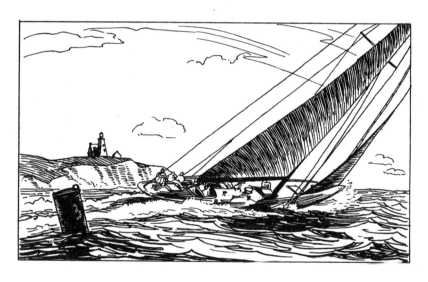

Here is an example suggesting speed by having the boat heading out of the picture. A balance can be achieved by placing one or two smaller objects near the edge of the opposite side.

Analysis

The center of interest is created by the opposing diagonal lines leading the eye to the buoy and the figures in the nearer boat. The boats have rounded the buoy and are heading for the next windward mark. This maneuver is called "tacking to windward."

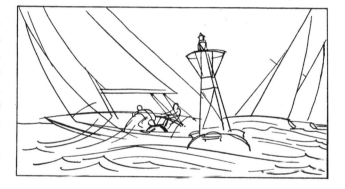

Poor Composition

Avoid placing the horizon in the middle of your composition. The boat in the center balanced by two clouds is very uninteresting.

TYPES OF SAILBOATS

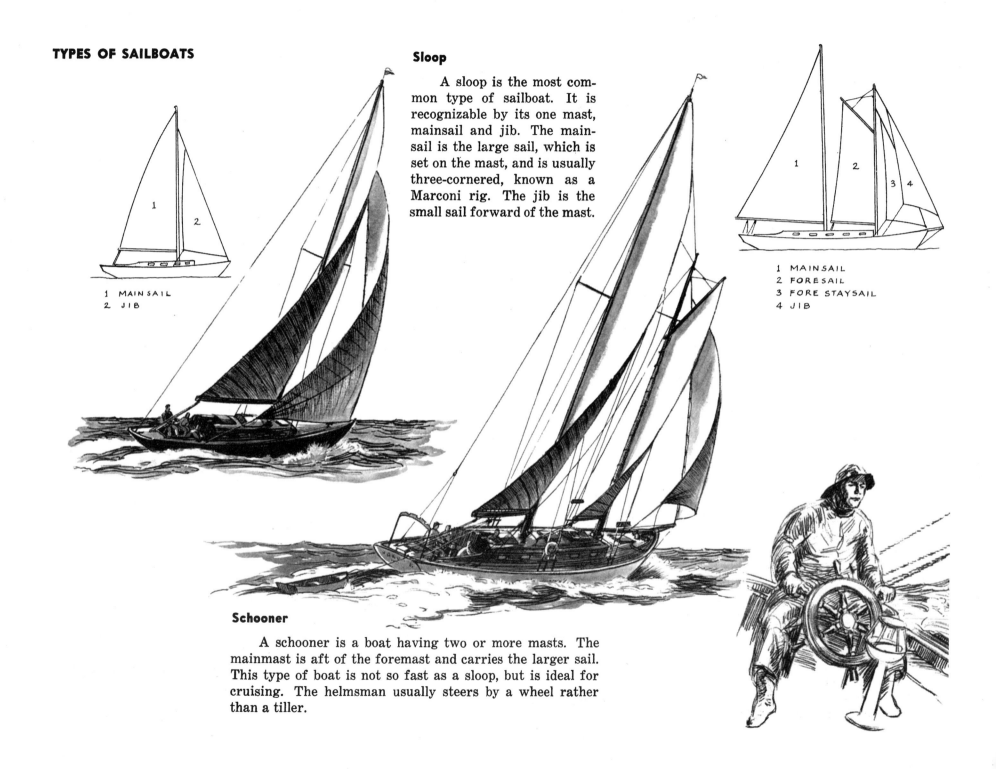

Sloop

A sloop is the most common type of sailboat. It is recognizable by its one mast, mainsail and jib. The mainsail is the large sail, which is set on the mast, and is usually three-cornered, known as a Marconi rig. The jib is the small sail forward of the mast.

1 MAINSAIL
2 JIB

1 MAINSAIL
2 FORESAIL
3 FORE STAYSAIL
4 JIB

Schooner

A schooner is a boat having two or more masts. The mainmast is aft of the foremast and carries the larger sail. This type of boat is not so fast as a sloop, but is ideal for cruising. The helmsman usually steers by a wheel rather than a tiller.

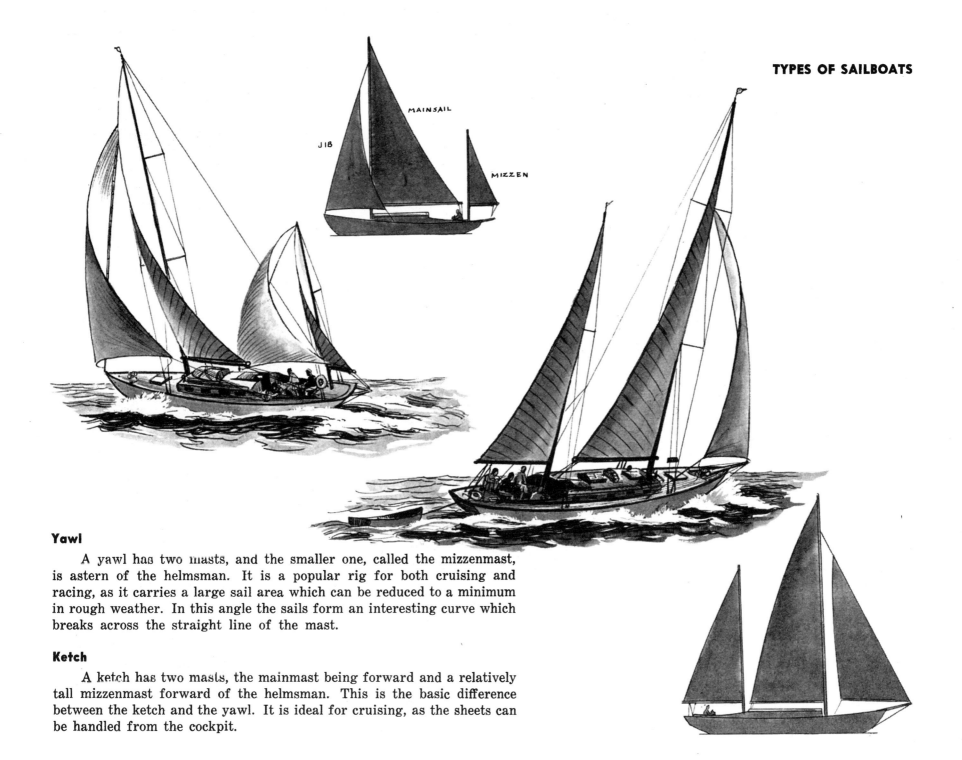

JIB

MAINSAIL

MIZZEN

Yawl

A yawl has two masts, and the smaller one, called the mizzenmast, is astern of the helmsman. It is a popular rig for both cruising and racing, as it carries a large sail area which can be reduced to a minimum in rough weather. In this angle the sails form an interesting curve which breaks across the straight line of the mast.

Ketch

A ketch has two masts, the mainmast being forward and a relatively tall mizzenmast forward of the helmsman. This is the basic difference between the ketch and the yawl. It is ideal for cruising, as the sheets can be handled from the cockpit.

RACING CLASSES

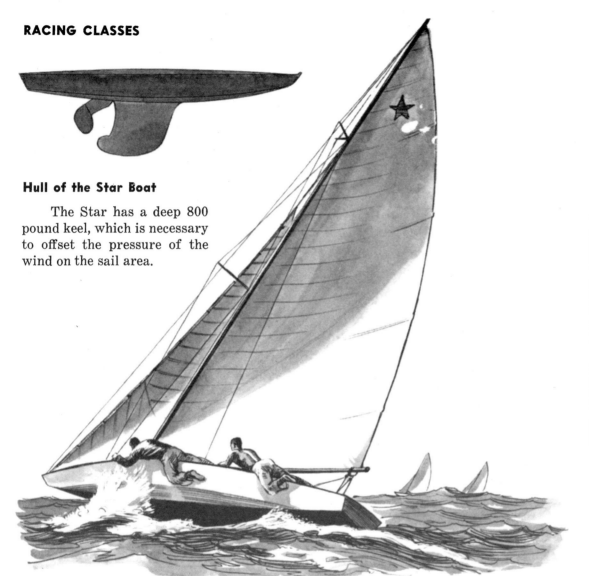

Hull of the Star Boat

The Star has a deep 800 pound keel, which is necessary to offset the pressure of the wind on the sail area.

Star Boat

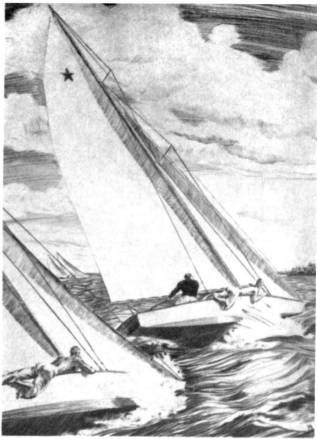

Star Class (Etching)

This is an International Class of racing boat that originated in the 1920's. It was designed purely for racing and is still one of the most popular classes of boats in all the yachting centers of the world.

The Star Boat is very interesting to draw. The crew is a definite part of the hull as they climb out to windward.

Hull of a Twelve Metre

This shows the smooth lines of the underwater part of the hull. The deep keel is finlike in shape to cut through the water.

Eight Metre Class

The metric system of measuring the waterline gives the name to these classes of racing yachts, such as six, eight, ten, and twelve metres.

Notice the tall mast and the slender lines of the sails when they are trimmed in flat for windward work.

Twelve Metre Class

This class was used in racing for the America's Cup in 1958. The sleek hull with long overhang at the bow and stern makes for great speed through the water with the least resistance. The large jib is called a genoa jib and overreaches the mainsail. It has a tremendous pull and is used mainly in light airs.

RACING CLASSES

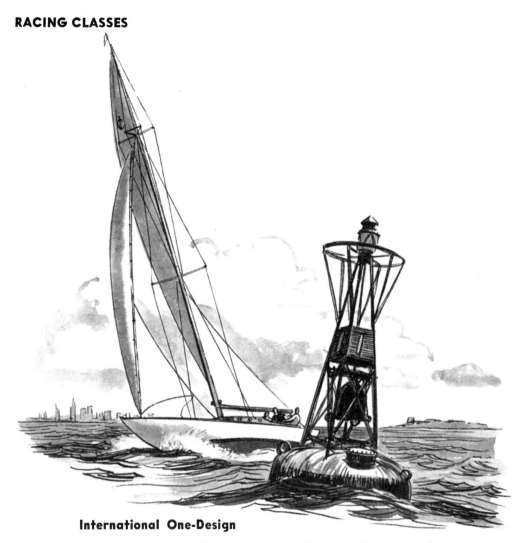

International One-Design

This class is sailed by some of the most famous yachtsmen of our time. Sketching the buoy in the foreground dramatizes the act of approaching the buoy, which is often used as a turning mark of the course. Here again, the graceful lines of the sails are contrasted with the straight lines of the mast and stays.

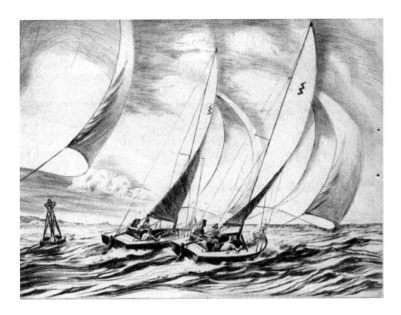

A Close Finish (Etching)

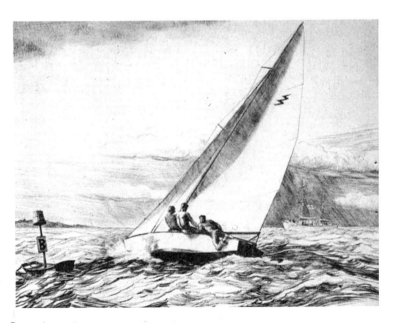

Crossing the Line (Etching)

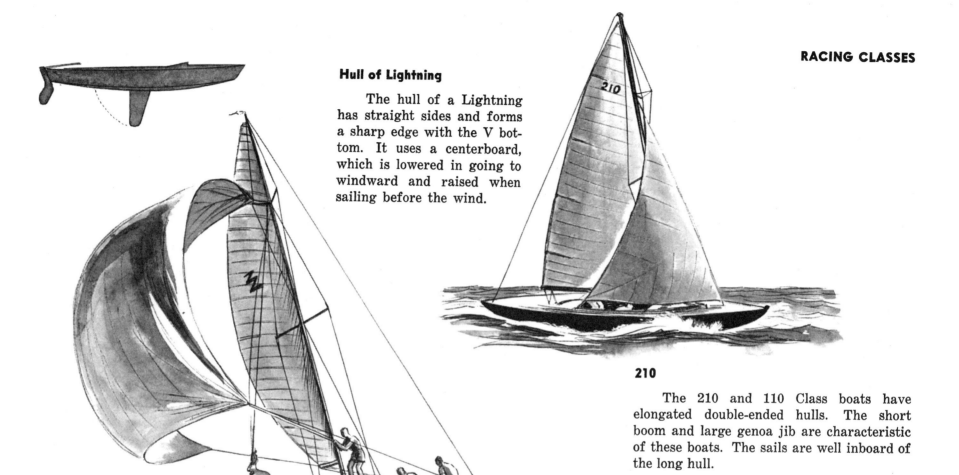

Hull of Lightning

The hull of a Lightning has straight sides and forms a sharp edge with the V bottom. It uses a centerboard, which is lowered in going to windward and raised when sailing before the wind.

210

The 210 and 110 Class boats have elongated double-ended hulls. The short boom and large genoa jib are characteristic of these boats. The sails are well inboard of the long hull.

Lightning Class

The Lightning Class is another International Class which is very active. The boat carries a crew of three, who are kept busy when setting a spinnaker, as in the above sketch.

On the opposite page are two etchings of Lightnings. One is crossing the line cross-hauled and shows the crew on the windward rail. The other is a close finish of two boats with spinnakers set.

On the Rail (Etching)

RACING CLASSES

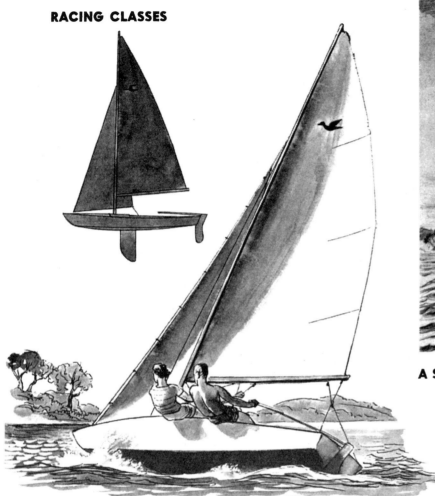

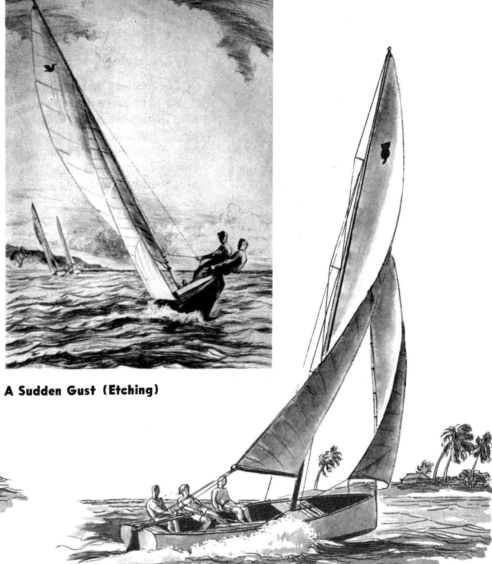

A Sudden Gust (Etching)

Snipe Class

The Snipe Class is the largest International Class of small boats. They are very popular on inland lakes and rivers as well as along the coast. These boats are interesting to draw as the crew is continually in action. In the sketch above notice how the action of the crew counteracts the diagonal line of the mast and sails.

Thistle Class

This is a very fast light type of boat that is gaining in popularity. It is a great thrill to sail a Thistle, especially with a good breeze astern. The boat starts to plane as the bow comes up and water moves under the hull. It takes a lively crew to handle a Thistle.

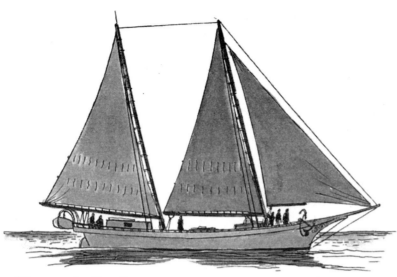

Chesapeake Bug-Eye

This boat has been a familiar sight on the Chesapeake Bay for over half a century. Primarily designed for dredging oysters, carrying cargo, etc., she has been refitted for pleasure sailing. Her characteristic two masts raked aft, clipper bow, and long, narrow lines in the deck are easily recognized.

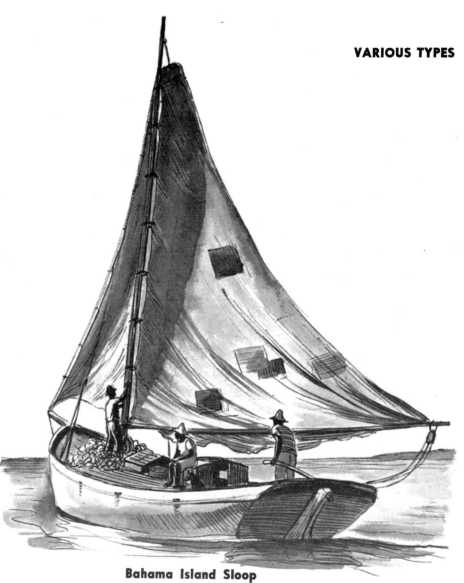

Bahama Island Sloop

This boat is ideal for an artist. Her hull has graceful, rounded lines; the sails are often patched with odd colors; and the boat seems to be held together with old ropes. She is used for carrying fish and other products to the market place.

It was these boats that Winslow Homer made famous early in the century in some of the finest water colors ever painted.

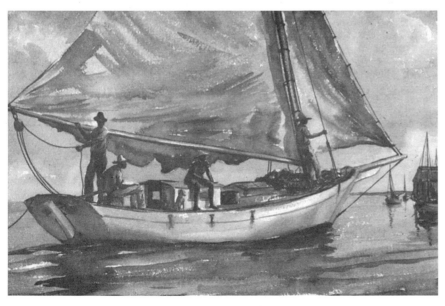

**Drifting Along
(Water Color)**

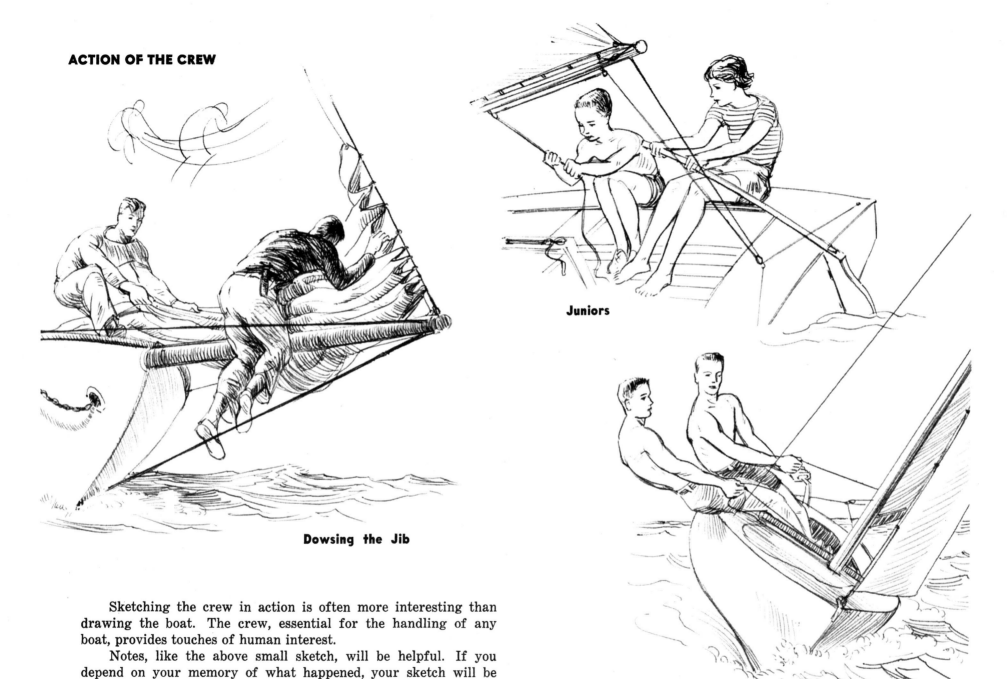

ACTION OF THE CREW

Dowsing the Jib

Juniors

Hiking Out in a "Jet 14"

Sketching the crew in action is often more interesting than drawing the boat. The crew, essential for the handling of any boat, provides touches of human interest.

Notes, like the above small sketch, will be helpful. If you depend on your memory of what happened, your sketch will be lacking in the convincing lines of action.

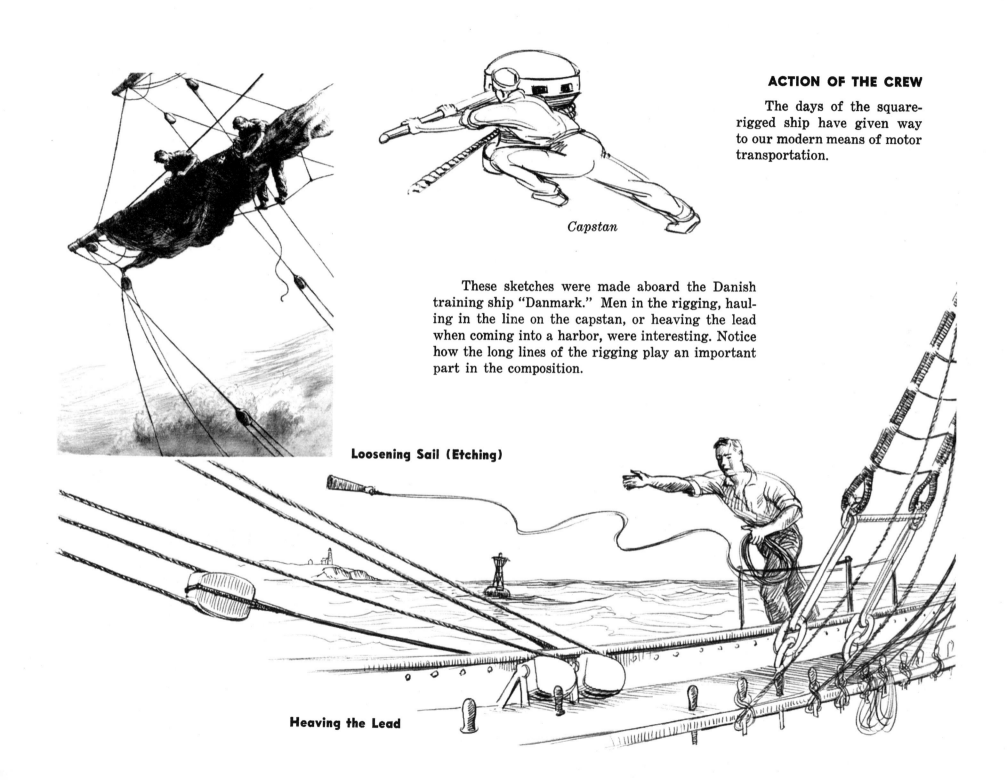

ACTION OF THE CREW

The days of the square-rigged ship have given way to our modern means of motor transportation.

Capstan

These sketches were made aboard the Danish training ship "Danmark." Men in the rigging, hauling in the line on the capstan, or heaving the lead when coming into a harbor, were interesting. Notice how the long lines of the rigging play an important part in the composition.

Loosening Sail (Etching)

Heaving the Lead

SAILS

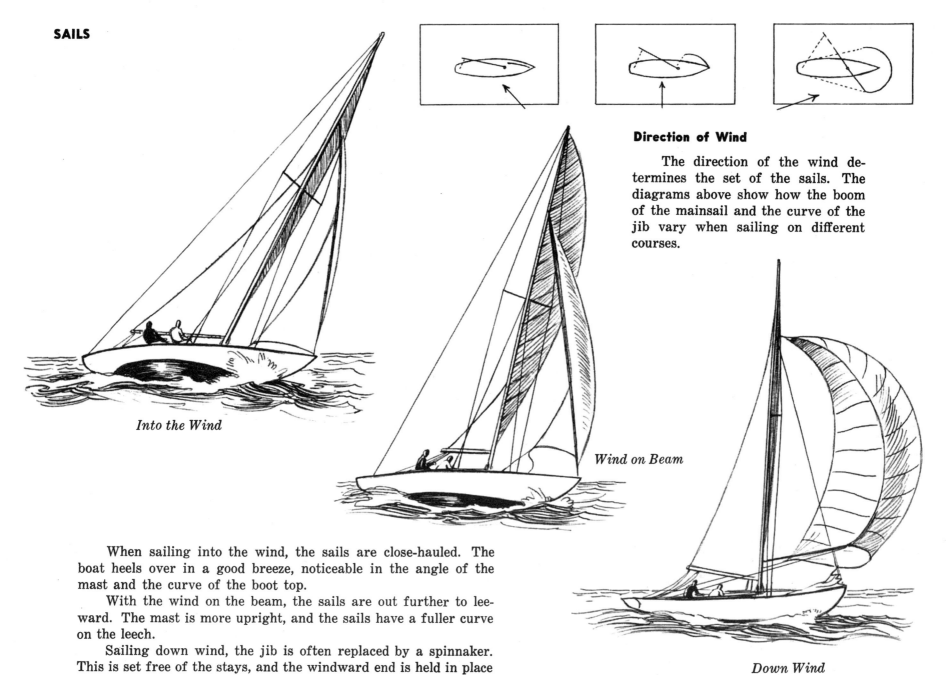

Direction of Wind

The direction of the wind determines the set of the sails. The diagrams above show how the boom of the mainsail and the curve of the jib vary when sailing on different courses.

Into the Wind

Wind on Beam

Down Wind

When sailing into the wind, the sails are close-hauled. The boat heels over in a good breeze, noticeable in the angle of the mast and the curve of the boot top.

With the wind on the beam, the sails are out further to leeward. The mast is more upright, and the sails have a fuller curve on the leech.

Sailing down wind, the jib is often replaced by a spinnaker. This is set free of the stays, and the windward end is held in place by a spinnaker pole, attached to the mast.

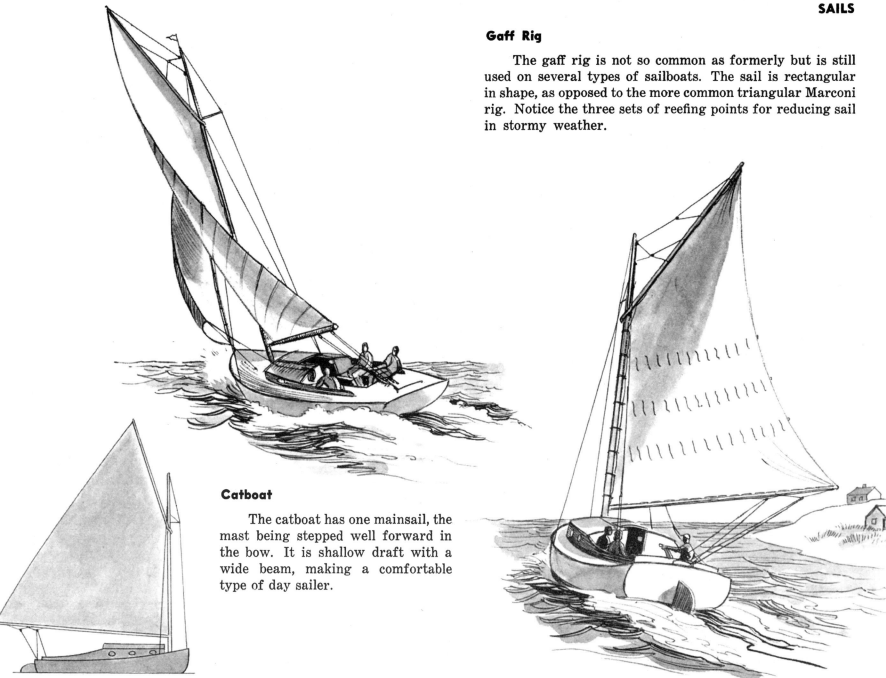

Gaff Rig

The gaff rig is not so common as formerly but is still used on several types of sailboats. The sail is rectangular in shape, as opposed to the more common triangular Marconi rig. Notice the three sets of reefing points for reducing sail in stormy weather.

Catboat

The catboat has one mainsail, the mast being stepped well forward in the bow. It is shallow draft with a wide beam, making a comfortable type of day sailer.

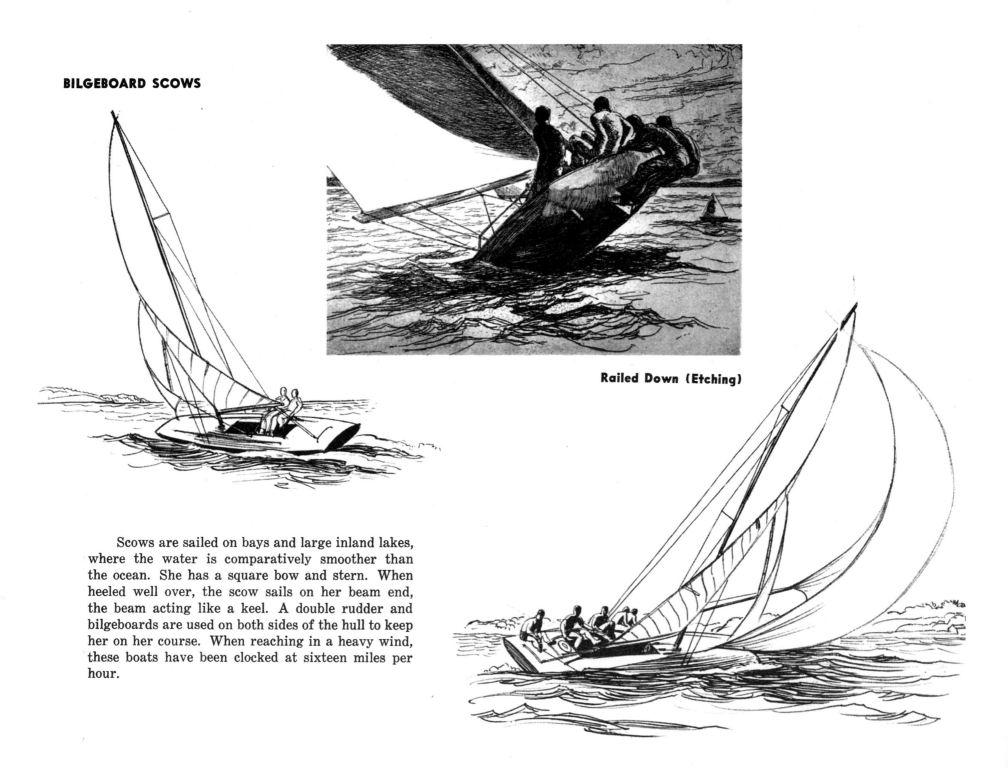

BILGEBOARD SCOWS

Railed Down (Etching)

Scows are sailed on bays and large inland lakes, where the water is comparatively smoother than the ocean. She has a square bow and stern. When heeled well over, the scow sails on her beam end, the beam acting like a keel. A double rudder and bilgeboards are used on both sides of the hull to keep her on her course. When reaching in a heavy wind, these boats have been clocked at sixteen miles per hour.

Nun

A nun buoy is red, even-numbered, and conical. It indicates that the channel is to port when entering a harbor.

Can

A can buoy is black, odd-numbered and cylindrical. It indicates that the channel is to starboard when entering a harbor.

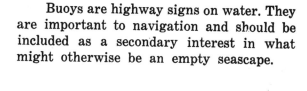

Buoys are highway signs on water. They are important to navigation and should be included as a secondary interest in what might otherwise be an empty seascape.

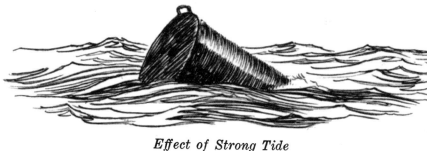

Effect of Strong Tide

Gong and bell buoys may be any color, depending on the location of the channel. They are usually placed at entrances to channels or harbors.

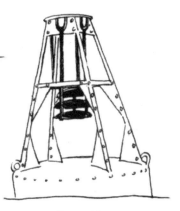

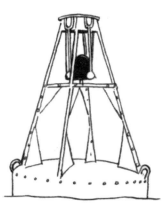

Lighted Bell Buoy

This type of buoy is used in deeper water. The clanging of the bell through a heavy fog is a sailor's delight.

Gong Buoy *Bell Buoy*

LIGHTHOUSES

If you live near the water, you will find that lighthouses are fascinating subjects to draw. Their function is to guide boats; therefore they have a definite part in marine art.

They usually are situated on a high cliff or out on a lonely island. In sketching them try to show the bleakness and severity of form and color.

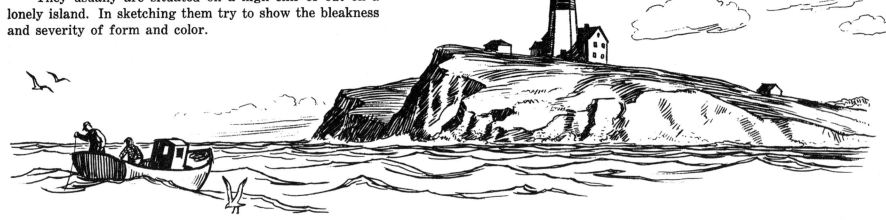

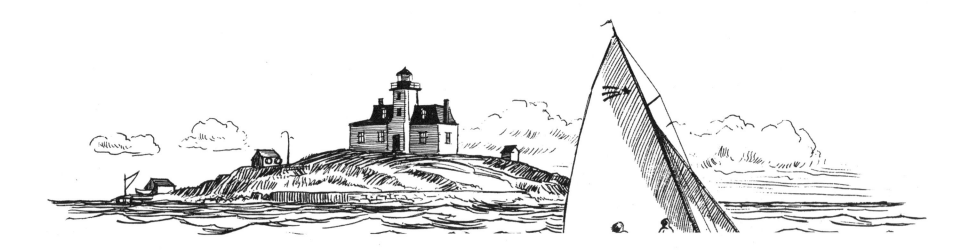

Latimer Reef (Etching)

Evening Light (Aquatint)

LIGHTHOUSES

This sketch is typical of many lighthouses marking a reef along the coast. If you are in a small boat near the level of the water, the cylindrical forms will appear more convex at the top than lower down. This helps create the feeling of height.

HORIZON

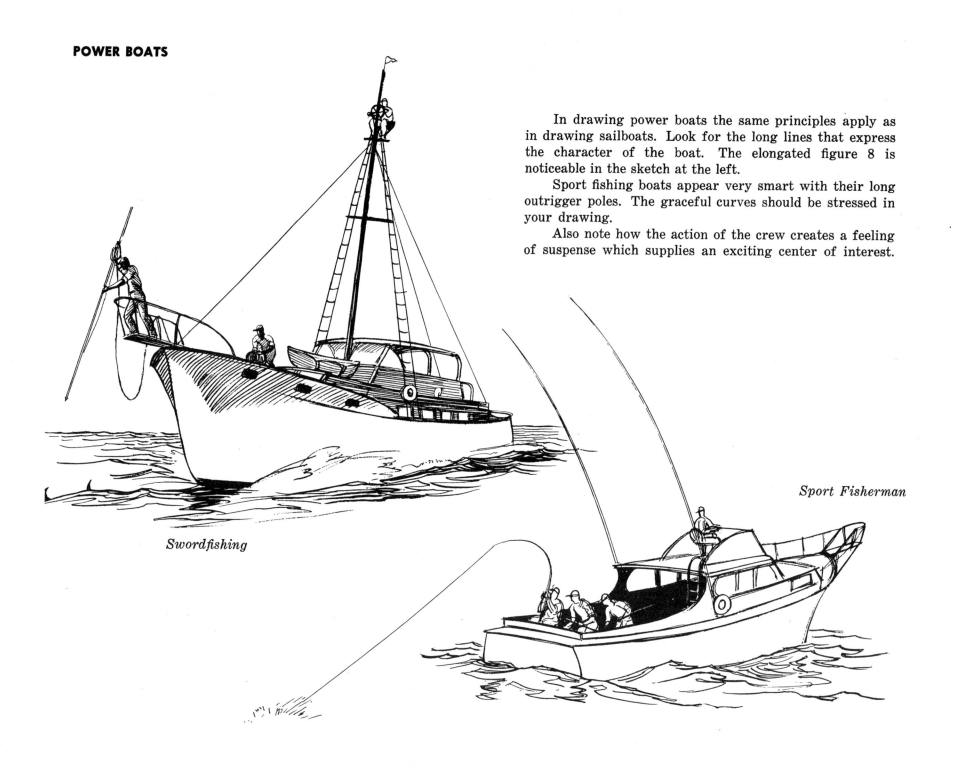

POWER BOATS

In drawing power boats the same principles apply as in drawing sailboats. Look for the long lines that express the character of the boat. The elongated figure 8 is noticeable in the sketch at the left.

Sport fishing boats appear very smart with their long outrigger poles. The graceful curves should be stressed in your drawing.

Also note how the action of the crew creates a feeling of suspense which supplies an exciting center of interest.

Swordfishing

Sport Fisherman

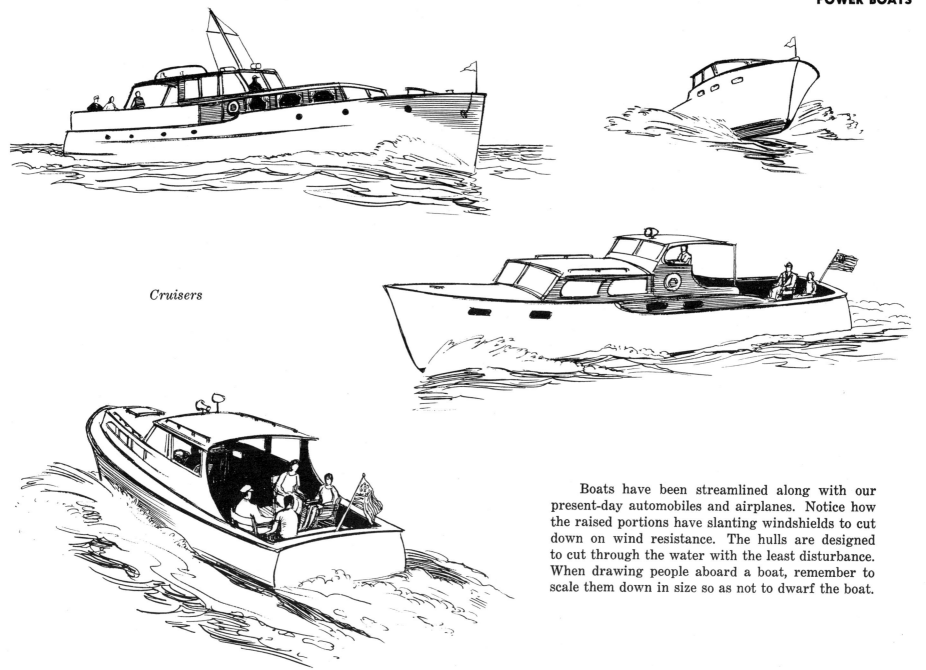

Cruisers

Boats have been streamlined along with our present-day automobiles and airplanes. Notice how the raised portions have slanting windshields to cut down on wind resistance. The hulls are designed to cut through the water with the least disturbance. When drawing people aboard a boat, remember to scale them down in size so as not to dwarf the boat.

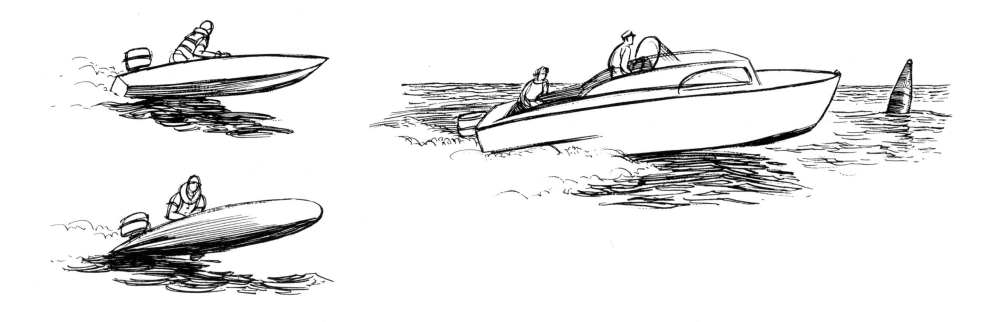

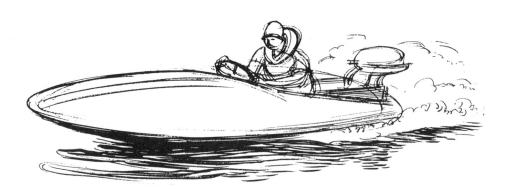

Outboard Cruiser

The speed of the boat can be emphasized by strong, forward lines. You can also create the feeling of speed by showing the boat leaping out of the water.

Outboard Runabouts

The oval shape of the outboard runabout is important in its design. By using circular forms in the figure you also achieve the effect of making the pilot part of the boat.

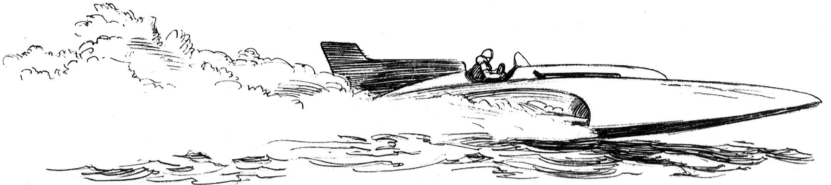

Speedboat

These boats travel so fast that it is only possible to get a fleeting impression. Only draw the most essential long lines. Try suggesting speed by showing a lot of spray as though it were jet-propelled.

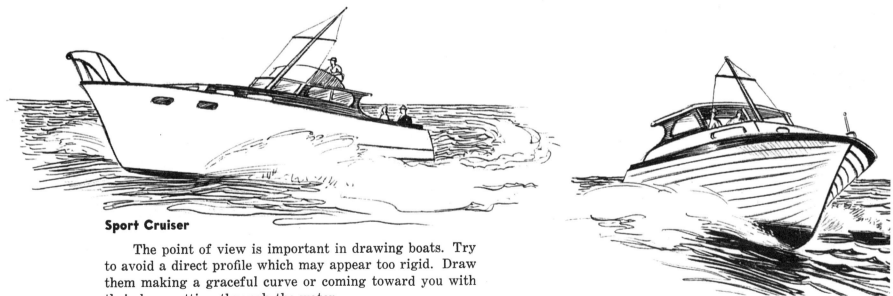

Sport Cruiser

The point of view is important in drawing boats. Try to avoid a direct profile which may appear too rigid. Draw them making a graceful curve or coming toward you with their bow cutting through the water.

Express Skiff

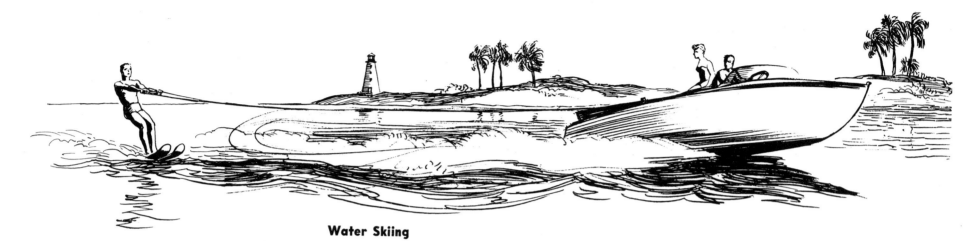

Water Skiing

This popular sport is fascinating to watch and to sketch. Study the well-timed movements of the skier and the figure 8 curves he makes as he swings from side to side. Attention can be focused on the skier by isolating him at one side, thereby balancing the composition.

Yacht Tender

When looking down on a boat, the horizon will appear in the upper part of the picture. The horizon is in the lower part when looking up at a boat.

This is a combination type of motorboat and sailboat. It may be rigged as a sloop, yawl, or ketch, depending on the size of the boat.

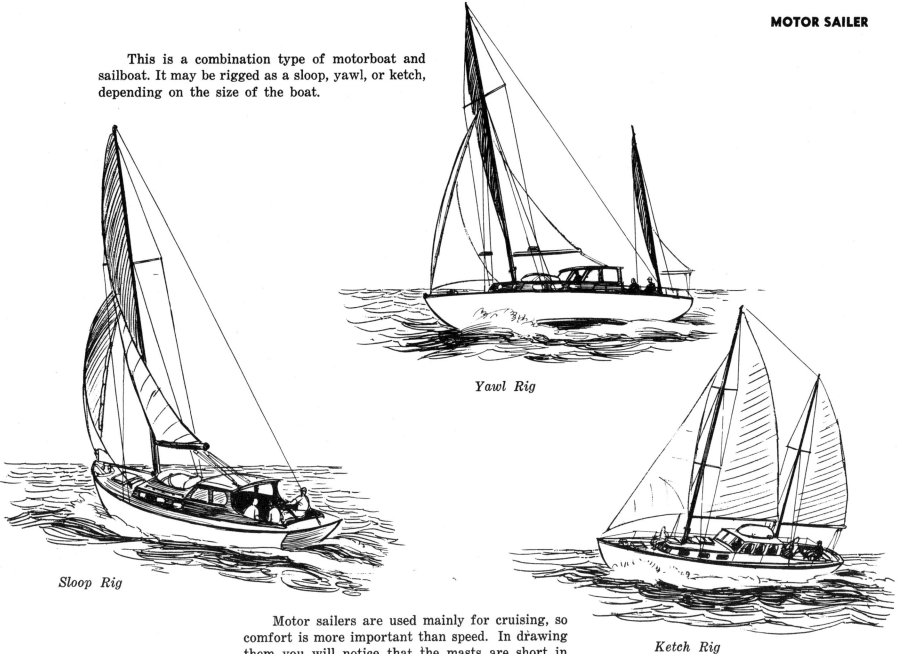

Yawl Rig

Sloop Rig

Ketch Rig

Motor sailers are used mainly for cruising, so comfort is more important than speed. In drawing them you will notice that the masts are short in proportion to the hull.

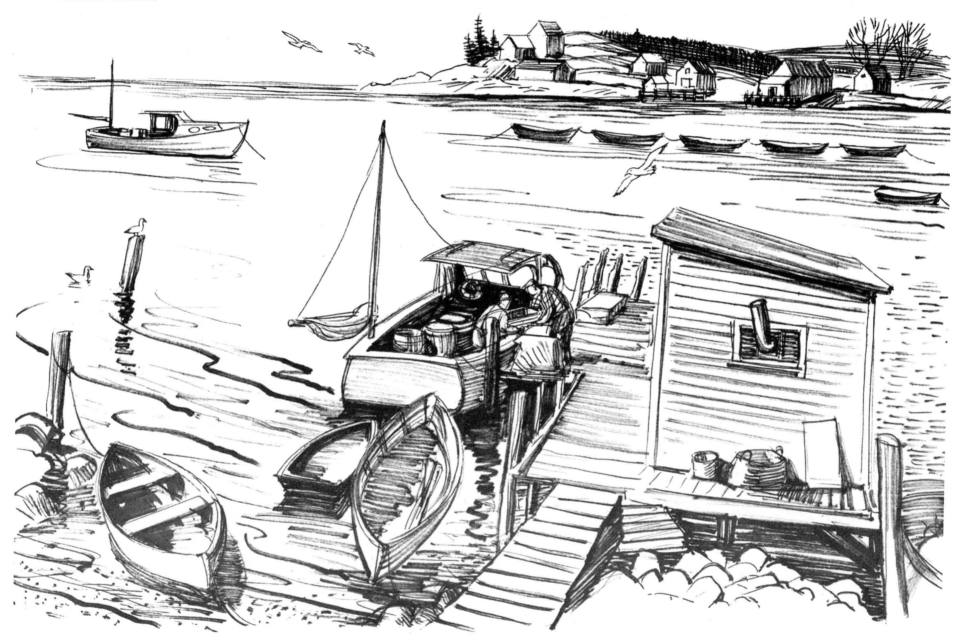

Lobster Boats and Dock

Fishing is a universal occupation. The various kinds of boats present interesting shapes to draw. Fishermen are friendly people and like to watch an artist sketching their boats.

These sketches were made with a felt pen. A felt pen enables you to get a quick sketch with rich contrasts ranging from black to light gray. Leave plenty of white paper showing or your sketches will become too "busy." Always simplify, leaving out any unnecessary details.

FISHING BOATS

Lobster Boat Heading Out To Sea

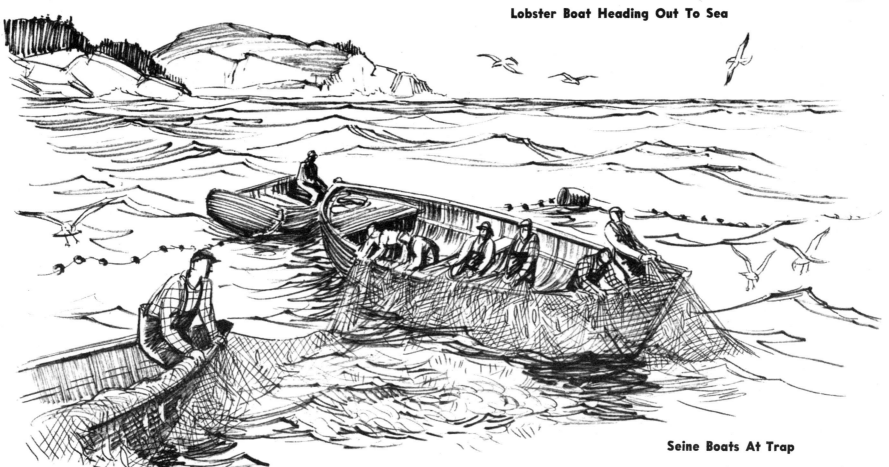

Seine Boats At Trap

Friendship Sloop

This sketch of a Friendship sloop was made at Friendship, Maine, where these boats were built many years ago. Originally they were used for fishing. As power boats replaced the sailboat for fishing, the Friendship sloop was eagerly sought for conversion to pleasure sailing.

They have a clipper bow which makes them distinctive from other boats. They usually are gaff-rigged and carry a large sail area.

The lines of the rigging in the sketch form a pyramid, creating a feeling of stability and repose while the boat is lying at her mooring.

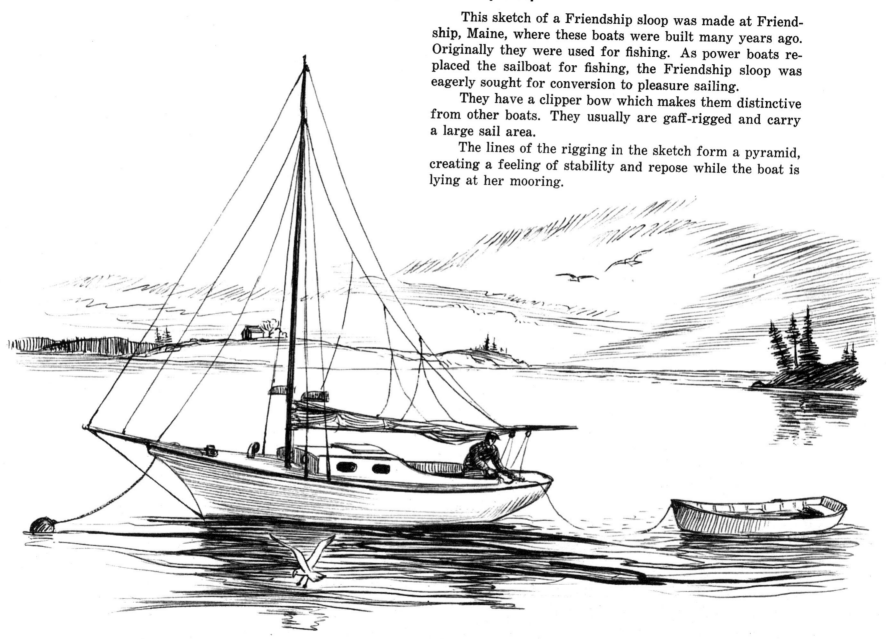

The dragger is used by commercial fishermen. The name is well suited, as the boat drags along the sea bottom a large net which is weighted down by heavy boards.

Hauling in the net is back-breaking work. Do not hesitate to exaggerate, either by distortion or by forcing the lines of action, in order to bring out your point of interest.

Gulls always are hovering above a fishing boat, looking for scraps of fish.

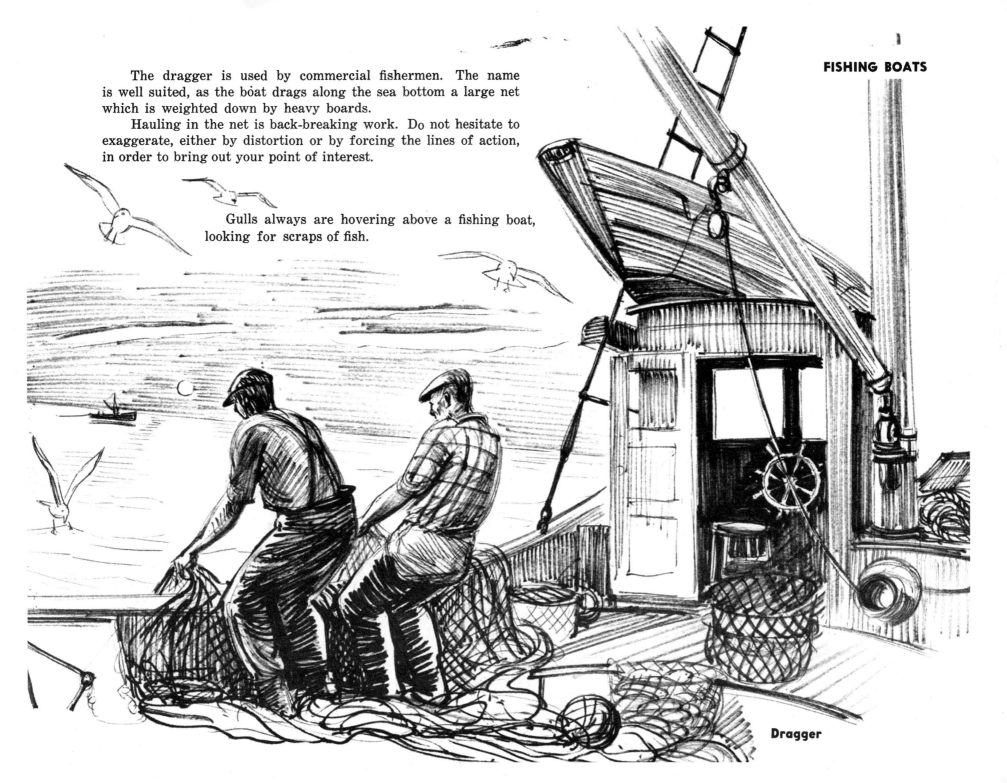

Dragger

FISHING BOATS
Shrimp Boat

Shrimp boats are found in Southern waters and especially in and around the Gulf of Mexico. The boats are painted bright colors, orange and blue predominating. They have a platform protruding over the stern.

If sketching in tropical waters, be sure to make sketches of the interesting cloud formations. They build up in huge perpendicular forms rather than in horizontal shapes.

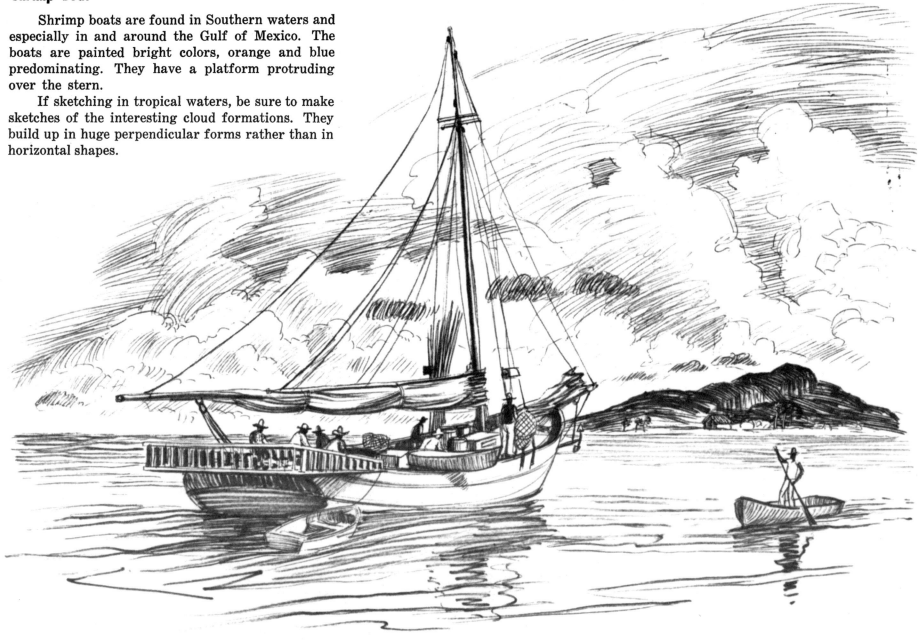

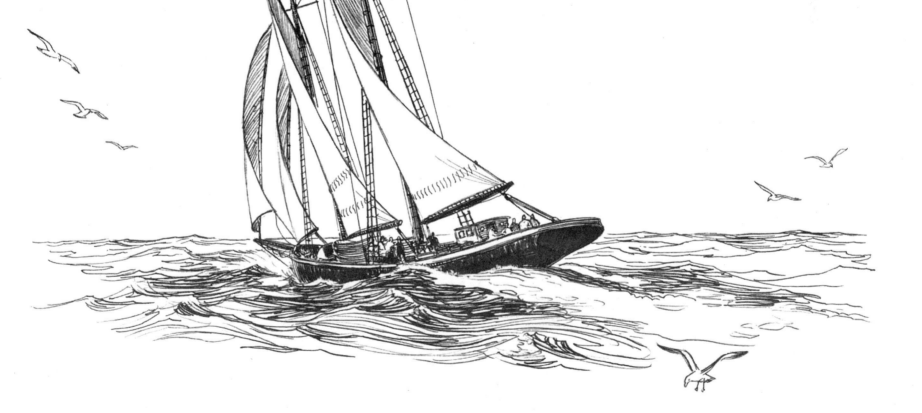

Bluenose

For many years Nova Scotia has been famous for its fishing schooners. The best known of these was the Bluenose. The boats go out to the Grand Bank for cod and are away from home for months at a time. Each fisherman has a dory which he paints in a color to differentiate it from those of his mates. The dories are stacked one in another on the decks.

In this angle the figure 8 is very noticeable in the sheer of the deck line.

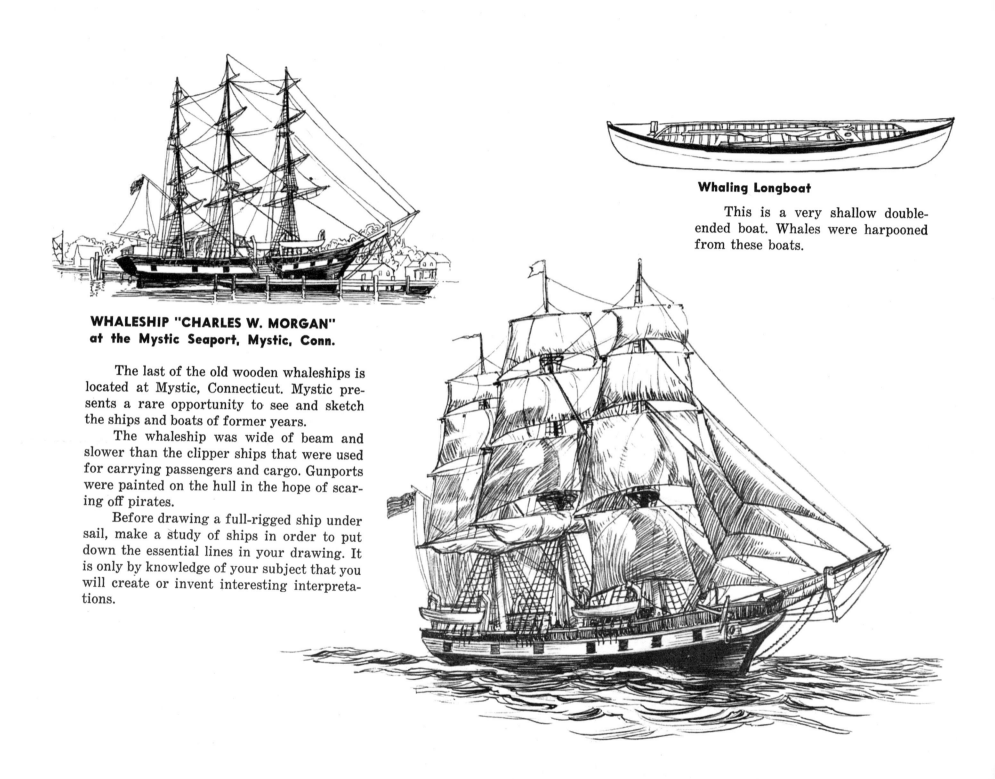

Whaling Longboat

This is a very shallow double-ended boat. Whales were harpooned from these boats.

WHALESHIP "CHARLES W. MORGAN" at the Mystic Seaport, Mystic, Conn.

The last of the old wooden whaleships is located at Mystic, Connecticut. Mystic presents a rare opportunity to see and sketch the ships and boats of former years.

The whaleship was wide of beam and slower than the clipper ships that were used for carrying passengers and cargo. Gunports were painted on the hull in the hope of scaring off pirates.

Before drawing a full-rigged ship under sail, make a study of ships in order to put down the essential lines in your drawing. It is only by knowledge of your subject that you will create or invent interesting interpretations.

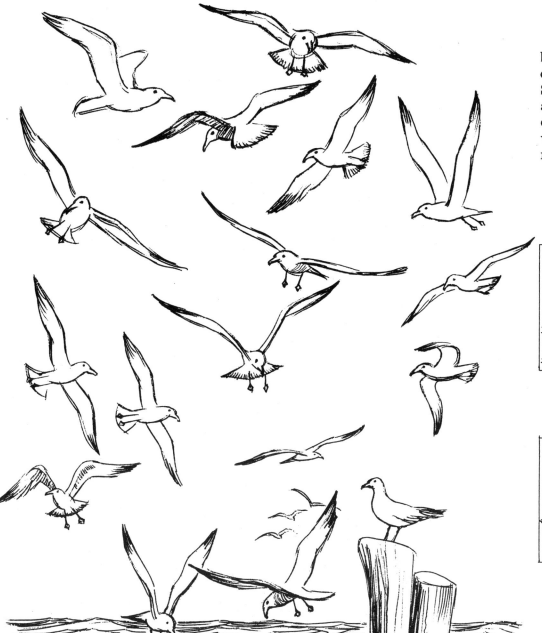

Gulls are the acrobats of the air. If you take a boat trip or a ferry ride, you will have a wonderful opportunity to sketch the gulls that follow the boat. Study their action in gliding on the wind, whirling about, dipping into the water for food, or banking on turns like jet planes in formation. Your sketches will be valuable later on for adding interest to a marine painting.

Wrong

Do not have gulls following a pleasure sailing boat. Do not draw gulls flying upside down as in the left side of the diagram.

Correct

Gulls are always around a fishing boat. Put some in the foreground so they form a part of your composition.

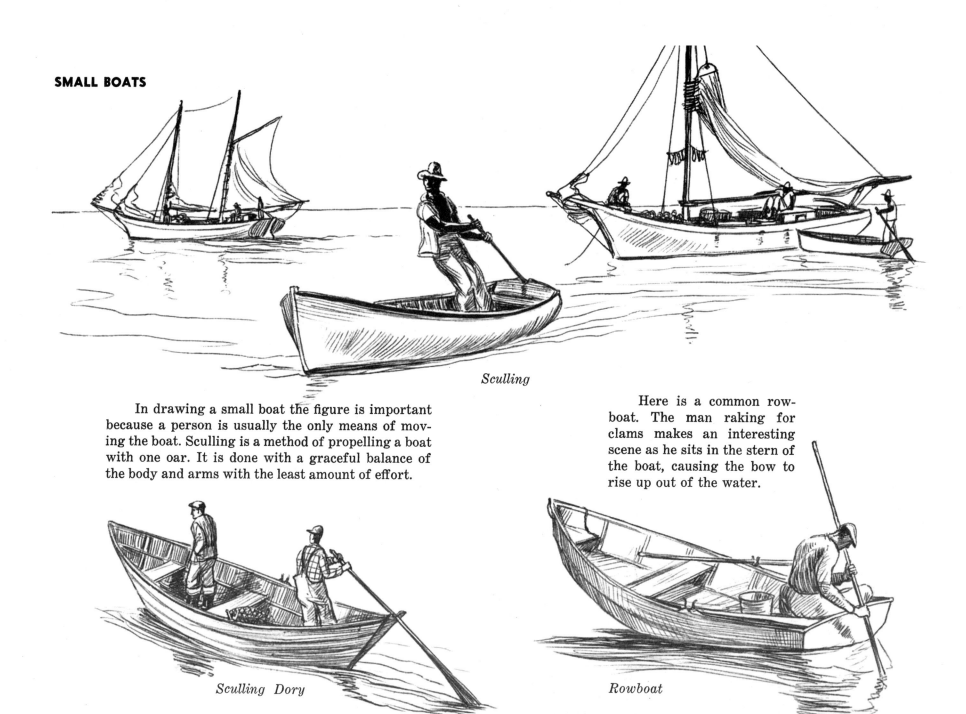

SMALL BOATS

Sculling

In drawing a small boat the figure is important because a person is usually the only means of moving the boat. Sculling is a method of propelling a boat with one oar. It is done with a graceful balance of the body and arms with the least amount of effort.

Here is a common rowboat. The man raking for clams makes an interesting scene as he sits in the stern of the boat, causing the bow to rise up out of the water.

Sculling Dory

Rowboat

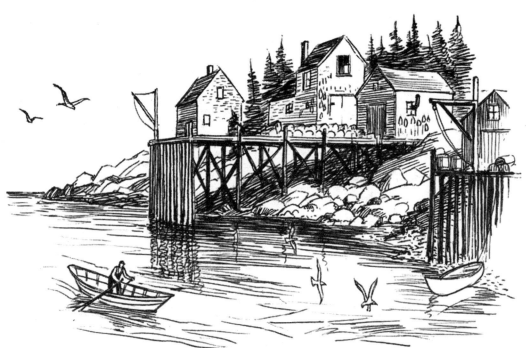

FISHING SHACKS

Along the coast you will find fishing shacks to sketch. Here the fisherman will be found mending his nets, making lobster traps or working on his boat.

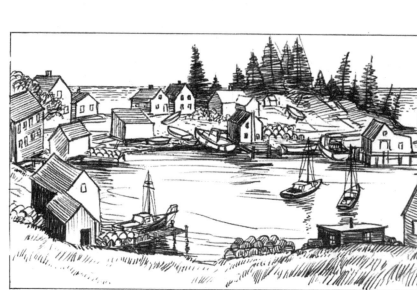

Look for an interesting point of view before starting to sketch. You will find it advantageous to look up at the docks which loom above when the tide is low. Or you may want to look down on a quiet harbor with the shacks at various angles to the harbor.

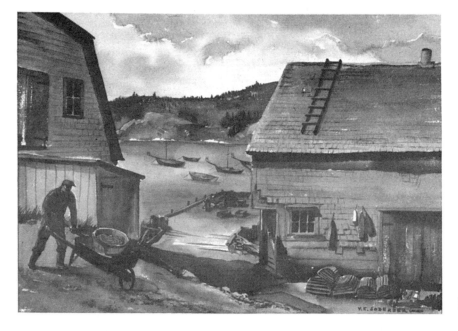

Fisherman's Wharf (Water Color)

TUGBOATS

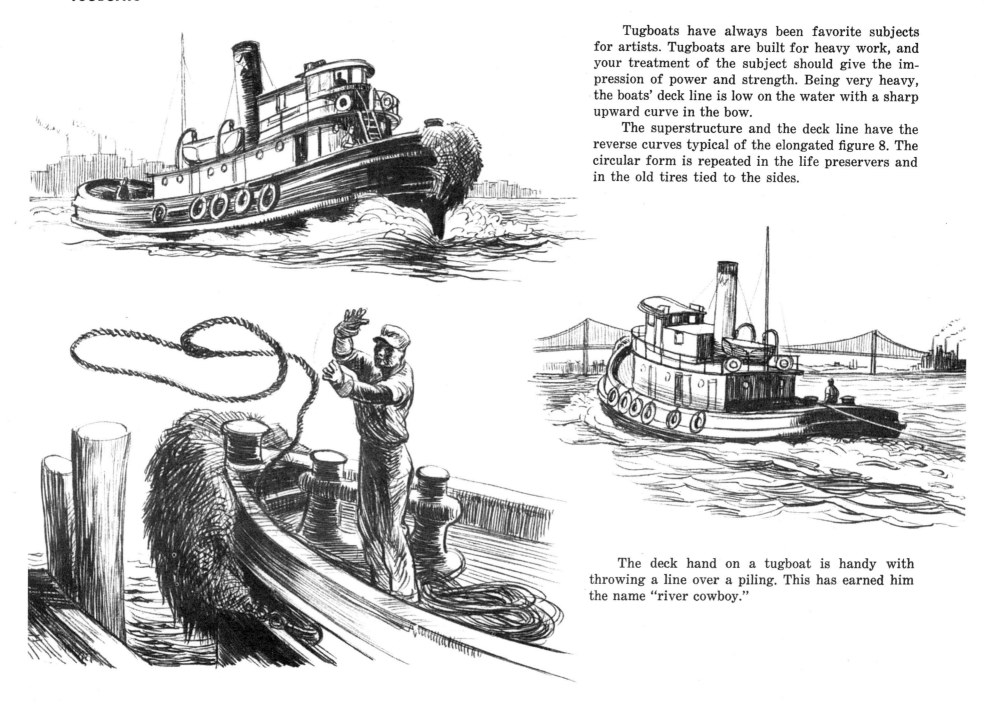

Tugboats have always been favorite subjects for artists. Tugboats are built for heavy work, and your treatment of the subject should give the impression of power and strength. Being very heavy, the boats' deck line is low on the water with a sharp upward curve in the bow.

The superstructure and the deck line have the reverse curves typical of the elongated figure 8. The circular form is repeated in the life preservers and in the old tires tied to the sides.

The deck hand on a tugboat is handy with throwing a line over a piling. This has earned him the name "river cowboy."

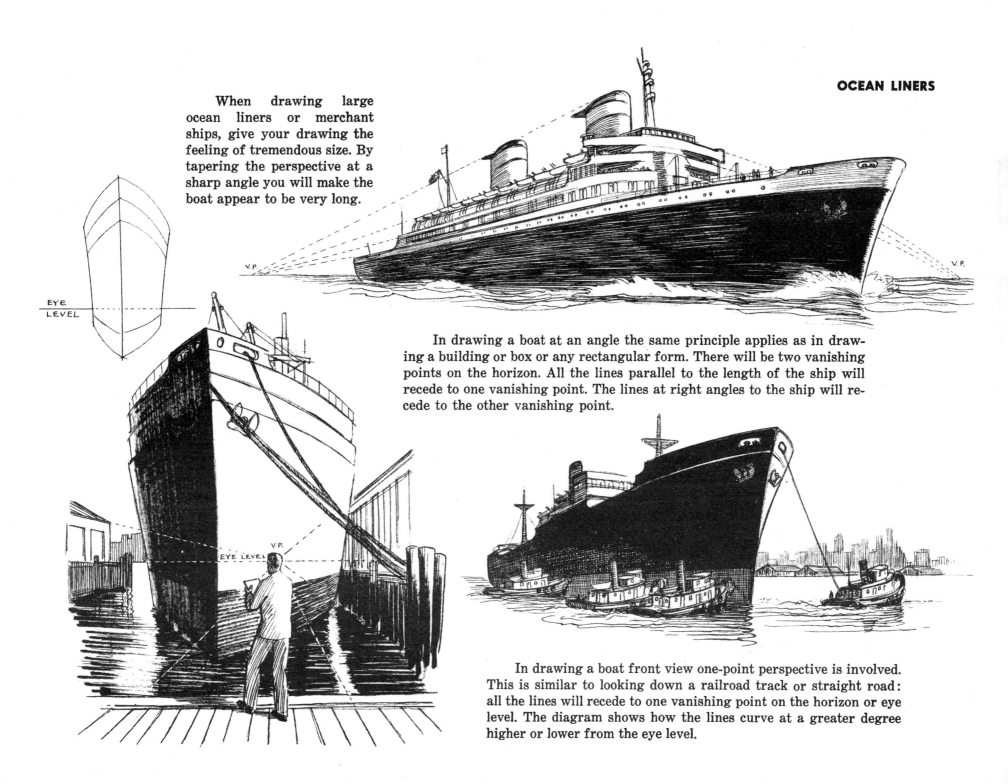

When drawing large ocean liners or merchant ships, give your drawing the feeling of tremendous size. By tapering the perspective at a sharp angle you will make the boat appear to be very long.

EYE LEVEL

V.P.

V.P.

In drawing a boat at an angle the same principle applies as in drawing a building or box or any rectangular form. There will be two vanishing points on the horizon. All the lines parallel to the length of the ship will recede to one vanishing point. The lines at right angles to the ship will recede to the other vanishing point.

V.P.

EYE LEVEL

In drawing a boat front view one-point perspective is involved. This is similar to looking down a railroad track or straight road: all the lines will recede to one vanishing point on the horizon or eye level. The diagram shows how the lines curve at a greater degree higher or lower from the eye level.

OTHER BOATS

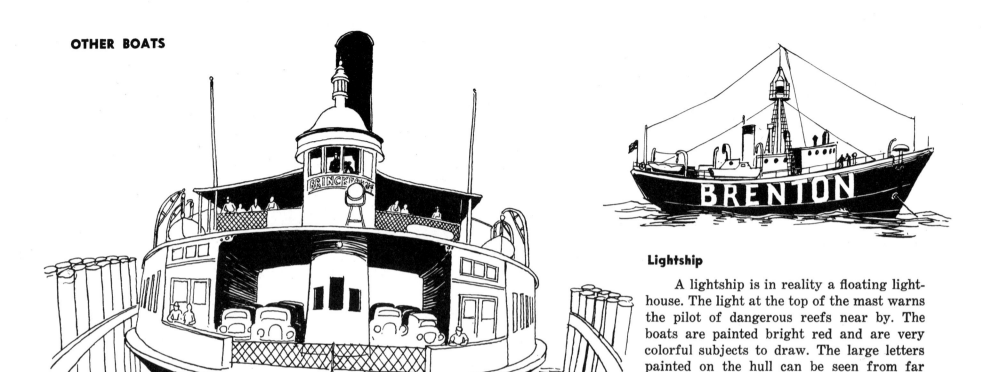

Lightship

A lightship is in reality a floating lighthouse. The light at the top of the mast warns the pilot of dangerous reefs near by. The boats are painted bright red and are very colorful subjects to draw. The large letters painted on the hull can be seen from far away. In foggy weather its foghorn sends out warnings to boats.

Ferryboat

A ferryboat is circular and squatty, which gives it a symmetrical appearance. When drawing one, think of a round tub floating on the water. It is important not only to train the hand to draw what the eye sees but also to train the mind to think of vital forms.

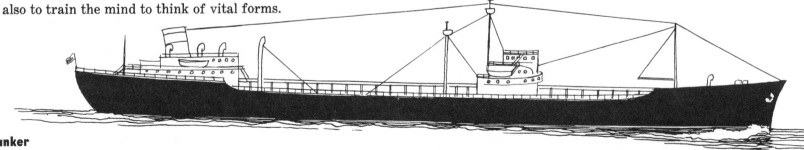

Tanker

There are several types of commercial boats that have the same characteristic of being very long and low in the water. The ore boats on the Great Lakes have a similar appearance. Here a side view is shown in order to emphasize the length of the boat.

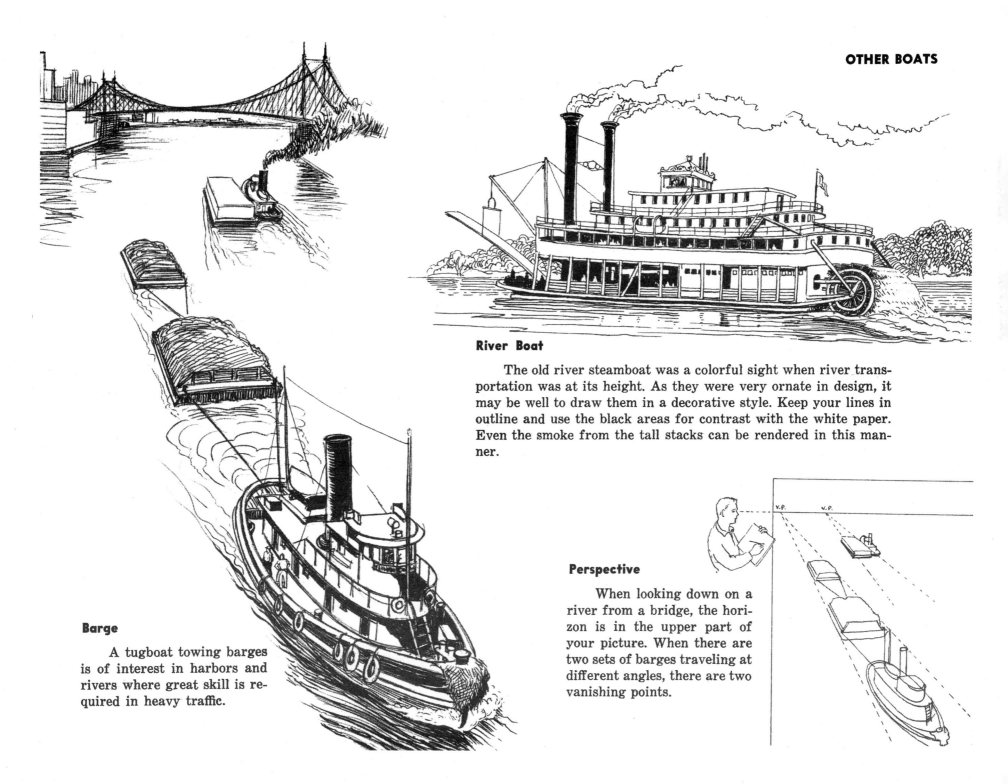

River Boat

The old river steamboat was a colorful sight when river transportation was at its height. As they were very ornate in design, it may be well to draw them in a decorative style. Keep your lines in outline and use the black areas for contrast with the white paper. Even the smoke from the tall stacks can be rendered in this manner.

Barge

A tugboat towing barges is of interest in harbors and rivers where great skill is required in heavy traffic.

Perspective

When looking down on a river from a bridge, the horizon is in the upper part of your picture. When there are two sets of barges traveling at different angles, there are two vanishing points.

NAVY SHIPS

Navy ships have a definite purpose in life, and they should be drawn with this in mind. Instead of being picturesque, they are powerful, businesslike craft. The clean lines of the submarine resemble a fish and suggest ability to travel fast under water as well as on the surface. A destroyer is bristling with guns and gives the feeling of speed in any type of sea.

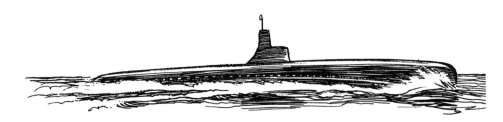

Submarine

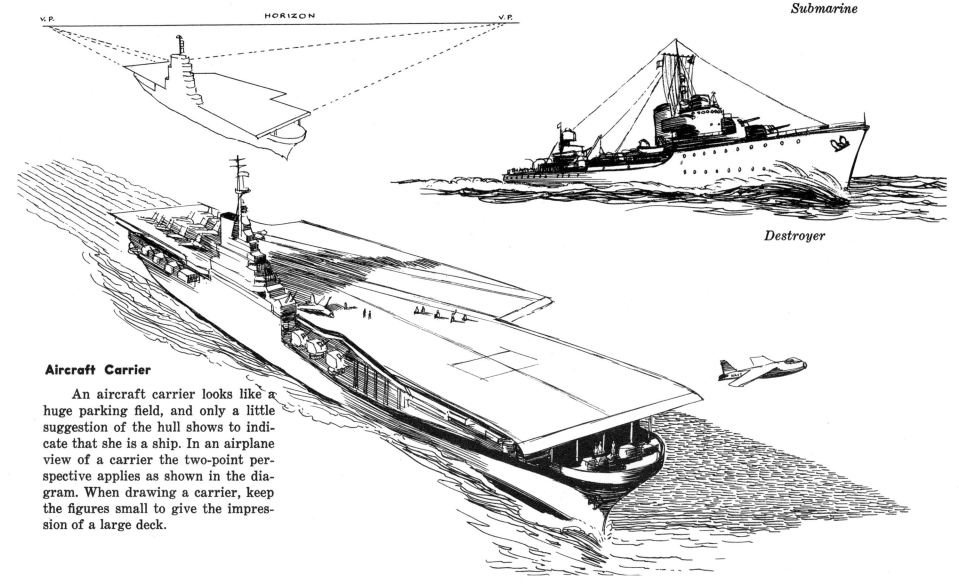

Destroyer

Aircraft Carrier

An aircraft carrier looks like a huge parking field, and only a little suggestion of the hull shows to indicate that she is a ship. In an airplane view of a carrier the two-point perspective applies as shown in the diagram. When drawing a carrier, keep the figures small to give the impression of a large deck.

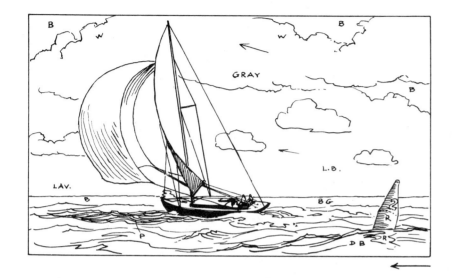

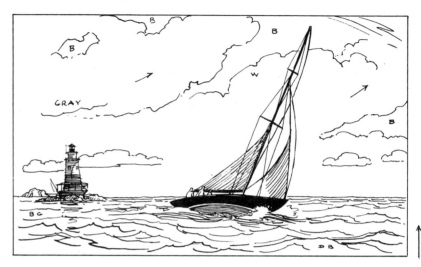

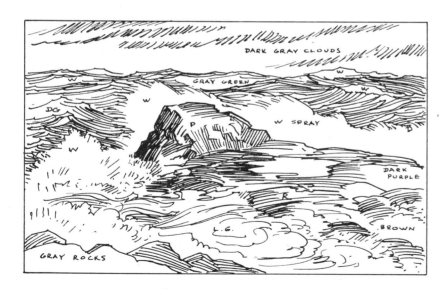

Wind Direction

As marine paintings have a large sky area, clouds become an important part of the composition. Be sure to give the impression that the clouds and waves are moving in the same direction as the wind.

You can indicate colors in your sketches by putting initials where you may want to remember the color.

Surf breaking on a rocky shore has been painted by many artists. Like most subjects of the sea, the waves are not good models—they do not stand still. It is by observing the continual motion of one wave succeeding another that you begin to feel the rhythm of the sea.

You will notice in the above sketches that the boat has been balanced by a buoy or lighthouse at one side. This is the same principle as a seesaw: a small child on the end can balance a larger person nearer the middle.

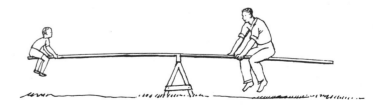

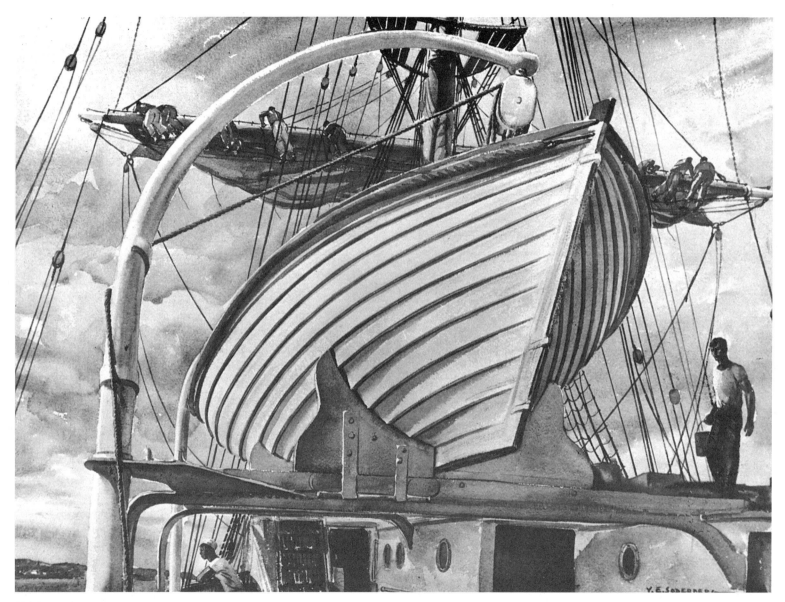

SODERBERG
Lifeboat (Water Color)
From the collection of
Mr. & Mrs. Martin Franich, Jr.
Reproduced by permission.

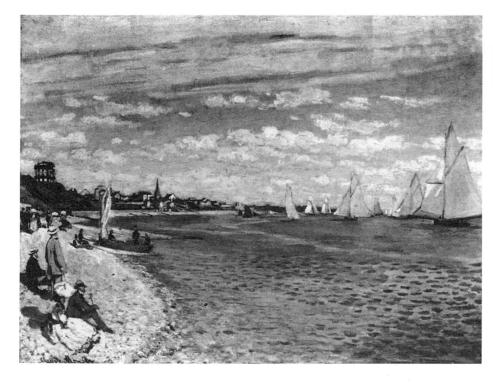

CLAUDE MONET
The Beach at Sainte Adresse
Courtesy of the Metropolitan Museum of Art
Bequest of William Church Osborn, 1951

ALBERT P. RYDER
Toilers of the Sea
Courtesy of the Metropolitan Museum of Art
George A. Hearn Fund, 1915

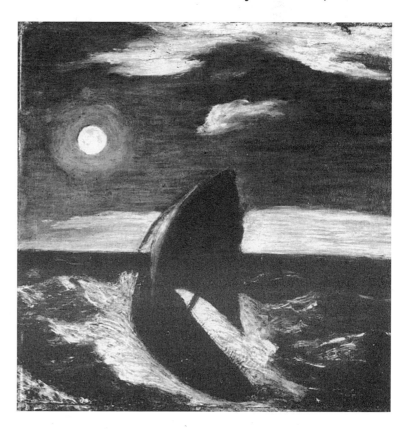

The marine paintings reproduced on this page show a wide range of interpretation of the subject: pleasure and work.

Claude Monet was one of the great French impressionists who brought painting away from the studio atmosphere into the outdoor colorful light and sunshine. This beach scene with the boats in the background sparkles with vibrant dots of color, making the viewer feel the life that was going on when Monet painted the scene.

Albert P. Ryder was an American artist who painted the sea in a dreamy moonlight atmosphere. Notice the simple composition leaving out all unnecessary details. He created a mood in his painting which gives the feeling of the lonely vastness of the sea.

IN CONCLUSION

In summing up *Drawing Boats and Ships* I would like to stress a few thoughts that were omitted in the preceding pages.

You will find a new world of adventure awaiting you when you go out sketching boats. It will also be a form of relaxation in this busy and complex life we lead.

The men who sail and live by the sea are wonderful people. In countries where I had difficulty speaking the language I found the people very interested in watching me sketch their boats. I have stayed in the homes of fishermen who could not read or write and found that the language of pictures can be understood by all. They were some of the most genuine people I ever knew.

Boats are not always the best models. They are continually on the move. Learn to sketch the essentials as quickly as possible. The details can be added later. Once a tugboat captain apologized to me for having to cast off the lines before I had finished my sketch.

You will have a lot of critics to offer advice or criticize some unimportant detail in the rigging. Remember: be truthful to yourself and to your convictions, or you will please no one.

Longing for the sea is an adventure that is still possible in our search for material in *Drawing Boats and Ships*.

GLOSSARY

Aft—in the direction of the stern.
Amidship—in the middle of the boat.
Astern—in or at the after, or stern, of a boat.
Battens—thin pieces of wood inserted in the leech of the sail to make it set flat.
Beam—the width of the boat at its widest portion.
Beat to windward—sailing to windward by tacking.
Before the wind—sailing with the wind coming from behind.
Boom—the horizontal spar that holds the foot of the mainsail.
Boom crotch—the support for the boom when not under sail.
Boot top—a stripe of paint marking the waterline of the hull.
Bow—the most forward part of the hull.
Can—a cylindrical buoy.
Centerboard—a vertical slab of wood or metal let down through the hull, to prevent a boat from slipping sideways.
Close-hauled—sails adjusted for sailing into the wind.

Cockpit—the part of the hull not covered over, where sailors sit.
Come about—turn from one tack to another, into the wind.
Fore and aft—lengthwise of the boat.
Forward—toward the bow.
Furl—roll a sail and secure it to the boom.
Headstay—a wire support running from the upper mast to the bow.
Heel—lean to one side.
Hull—the body of the boat.
Jib—a three-cornered sail set forward of the mast.
Jibe—changing tack by turning the boat's stern, rather than the bow, through the wind.
Leech—the after edge of a sail.
Leeward—the side away from the wind.
Mainsail—the large sail set on the mainmast.
Marconi rig—a three-cornered fore and aft sail.
Mast—a vertical pole for supporting sails.
Mooring—an anchorage marked by a buoy.
Nun—a cone-shaped buoy.
Off the wind—away from the direction of the wind.

On the wind—sailing as close as possible toward the wind direction.
Port—the left side of a boat when facing forward.
Port tack—sailing with the wind coming over the port side.
Reefing points—used for shortening sail.
Rigging—all the ropes and lines of a boat.
Rudder—the flat, underwater steering gear at the stern of a boat.
Sheet—the line used to adjust a sail.
Spars—all masts and booms.
Spinnaker—a large, balloon-shaped sail set forward free of stays when sailing before the wind.
Starboard—the right side of a boat when facing the bow.
Starboard tack—sailing with the wind coming over the starboard side.
Stays—the supports of the mast.
Stern—the back end of a boat.
Tack—change course by sailing into the wind.
Tiller—the wooden or metal arm used in moving a rudder.
Windward—the direction from which the wind is blowing.